*"An invisible red thread connects those who are destined
to meet, regardless of time, place or circumstances.
The thread may stretch or tangle, but will never break."*
— EARLY CHINESE BELIEF

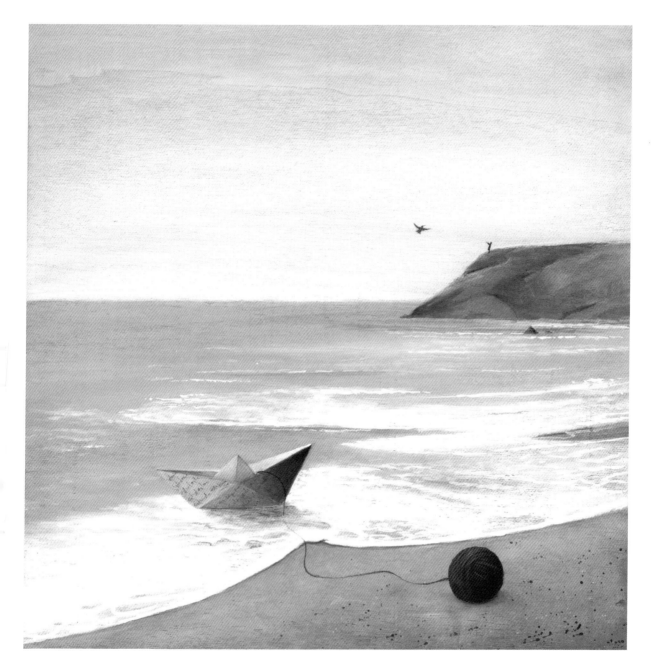

Dedicated to You

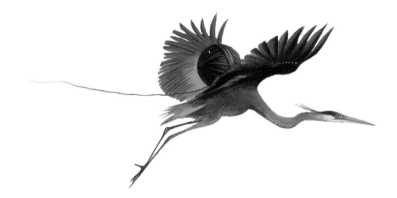

Mr. M
& The Red Thread

Soizick Meister

Words by K. George

READ LEAF

Abandoning anomie,
Mr. M pursues happiness.

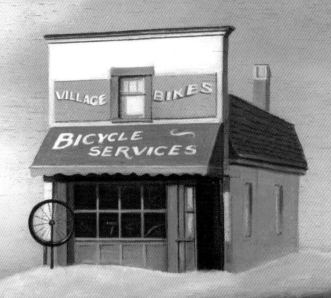

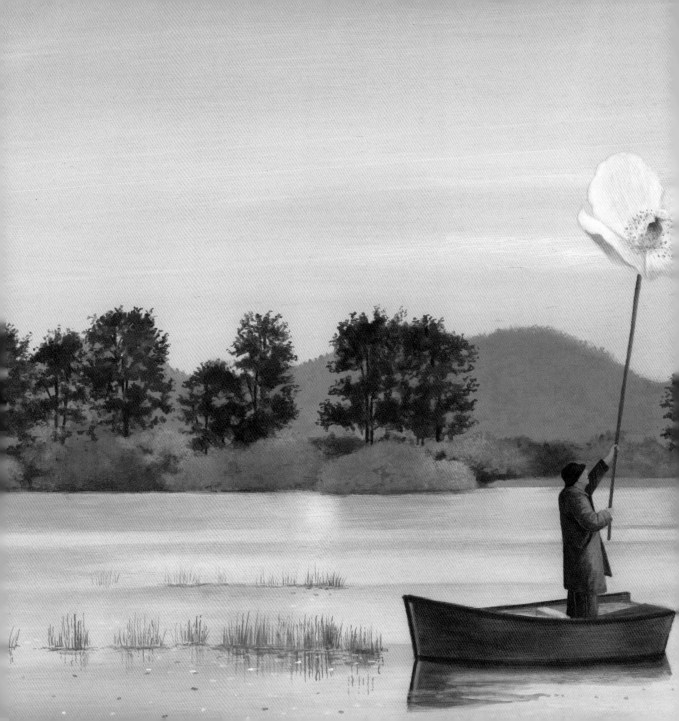

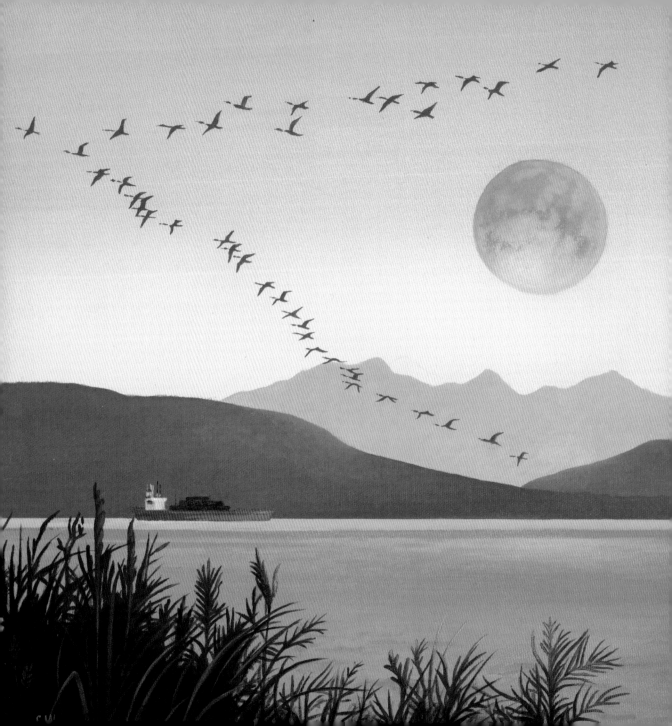

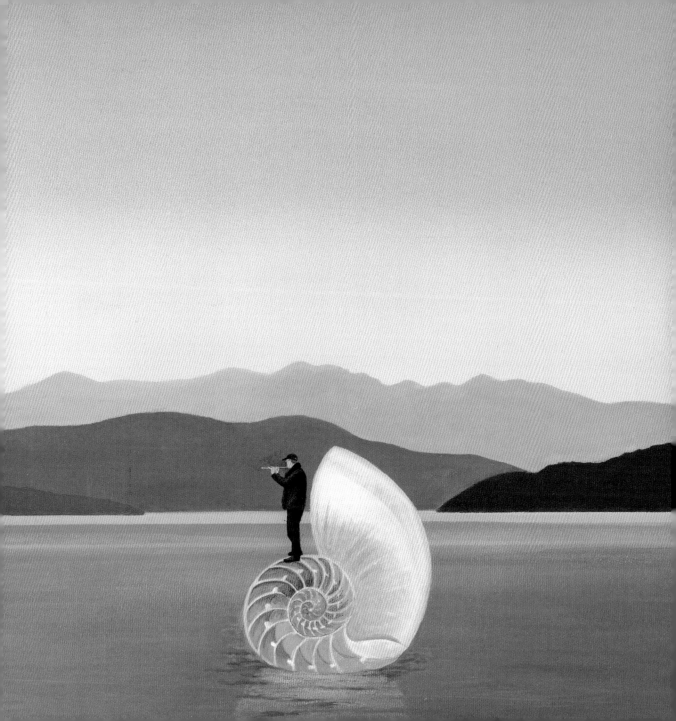

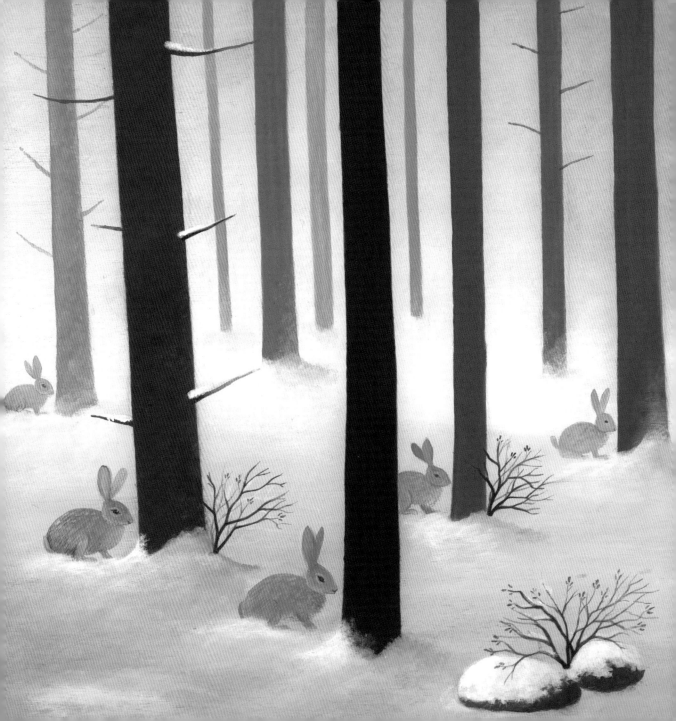

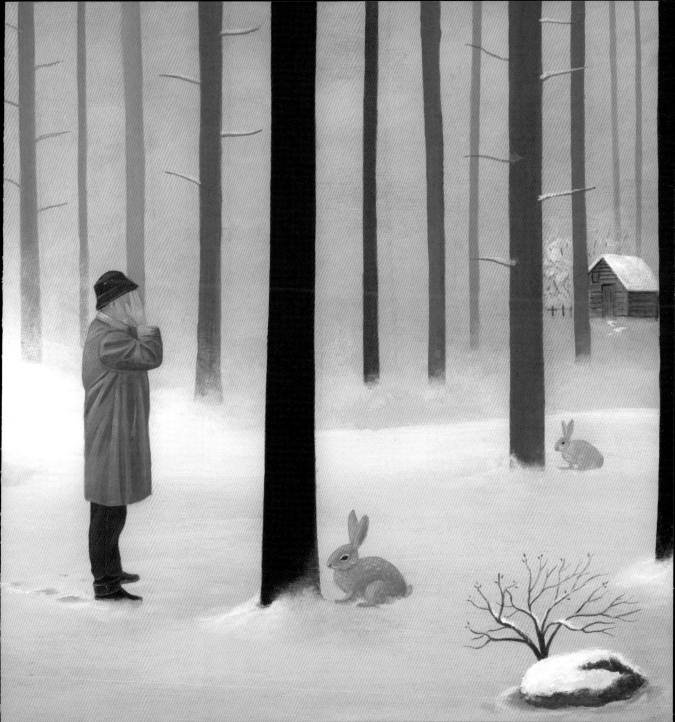

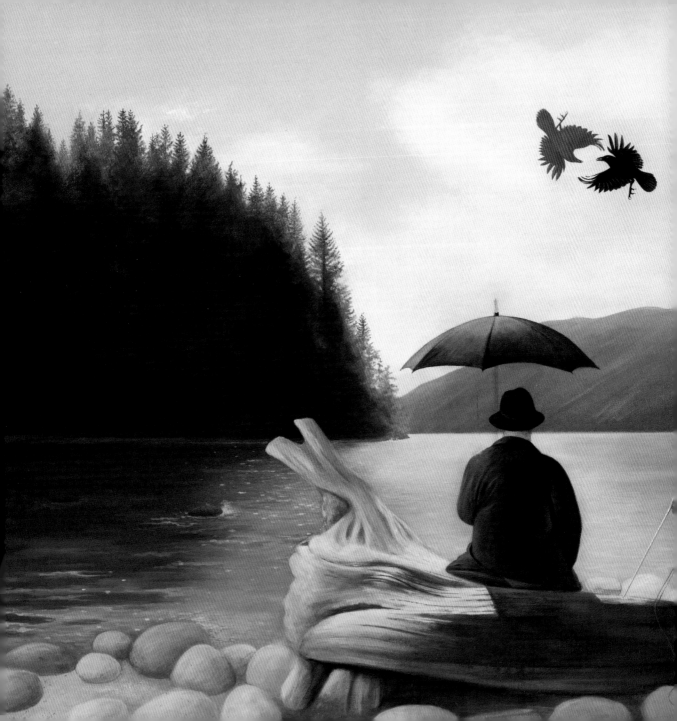

A tryst of long ago rekindles his longing for companionship.

Memories become messages.

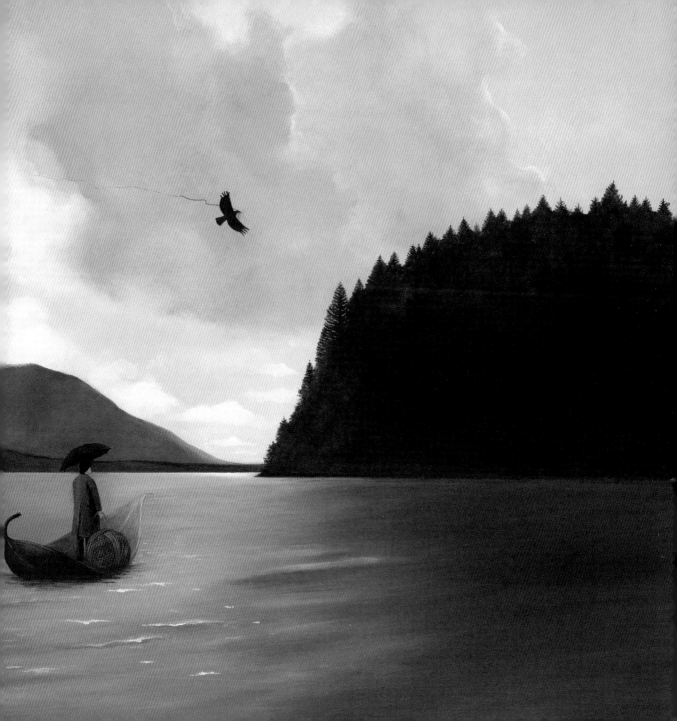

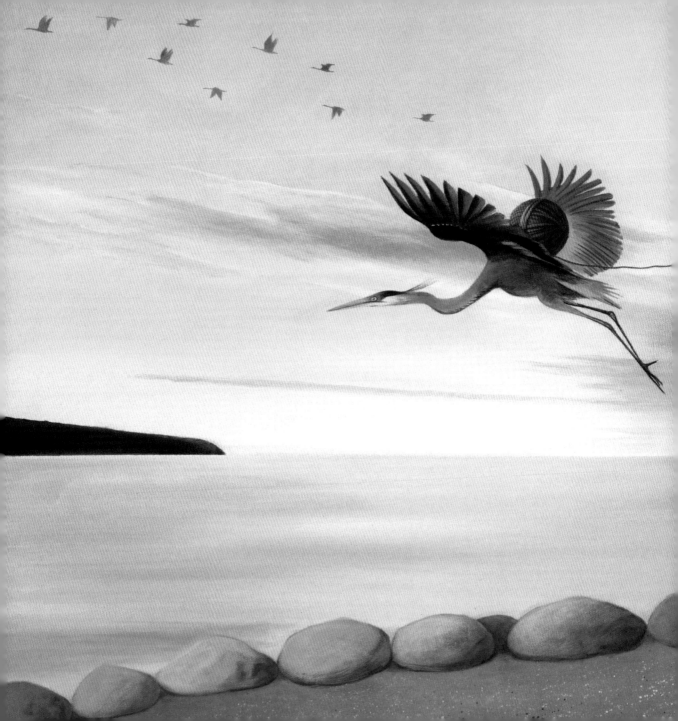

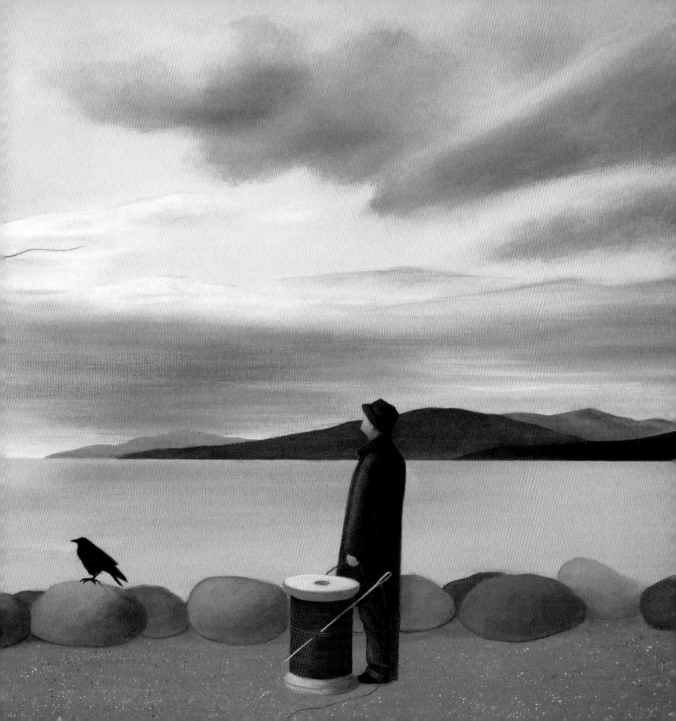

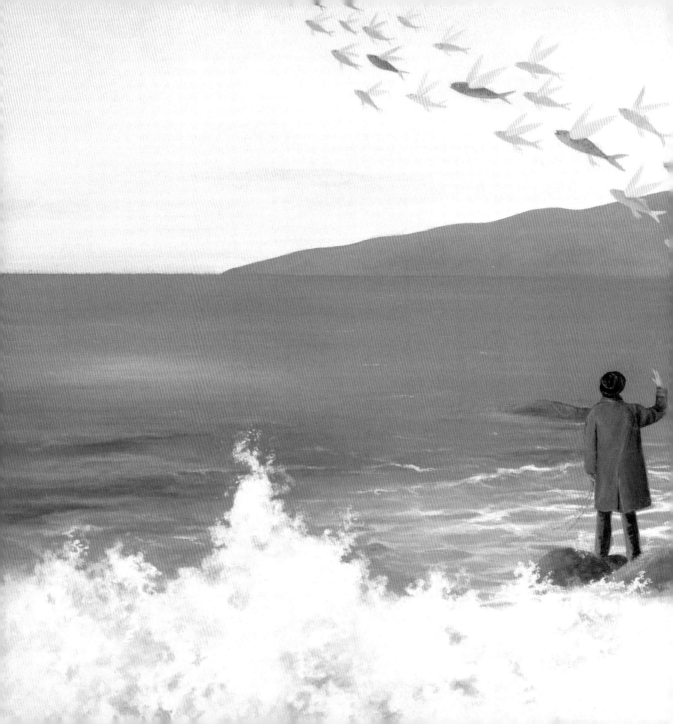

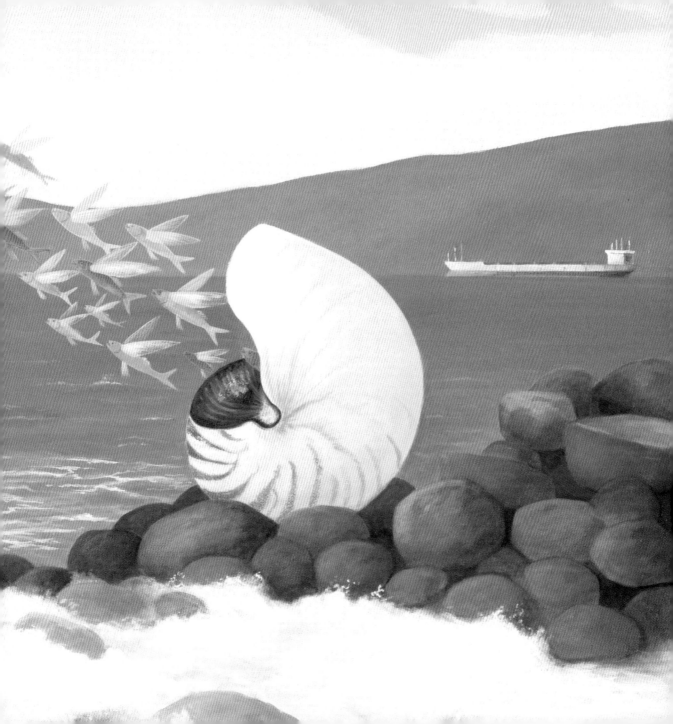

Perched precariously, he waits.

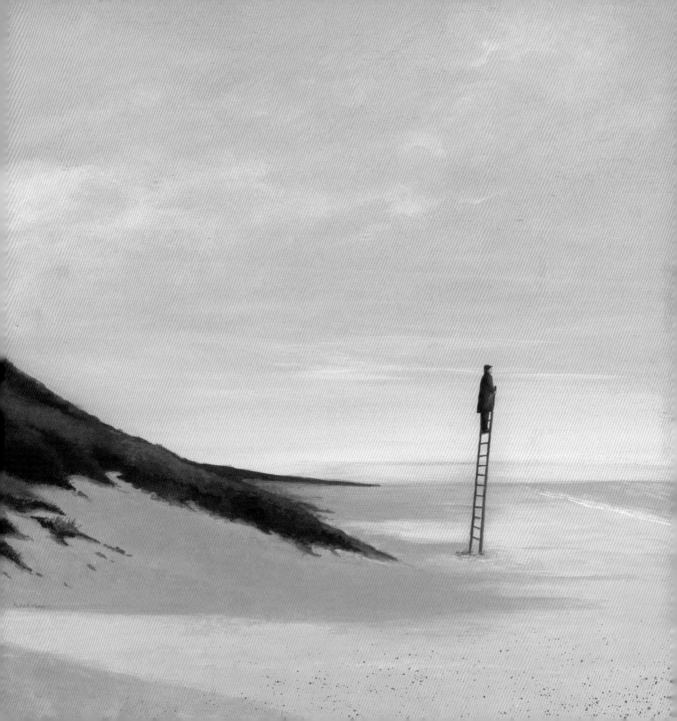

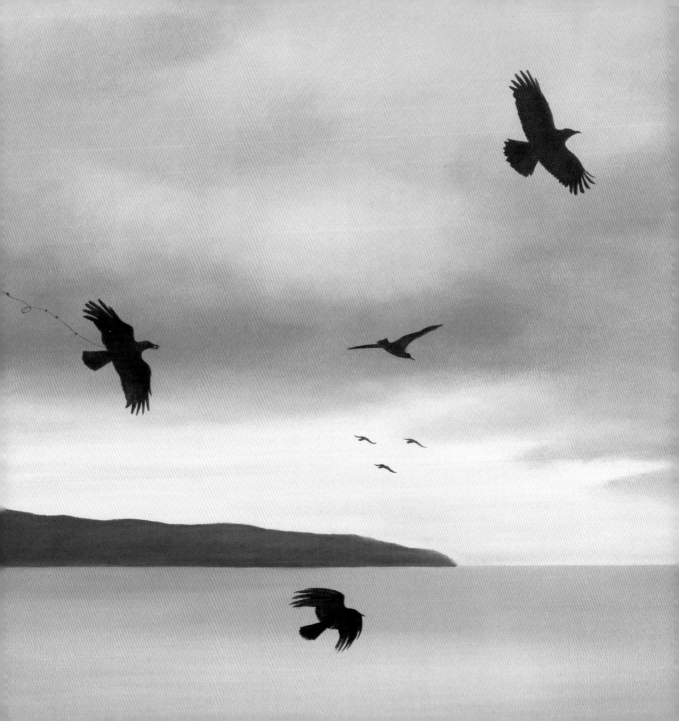

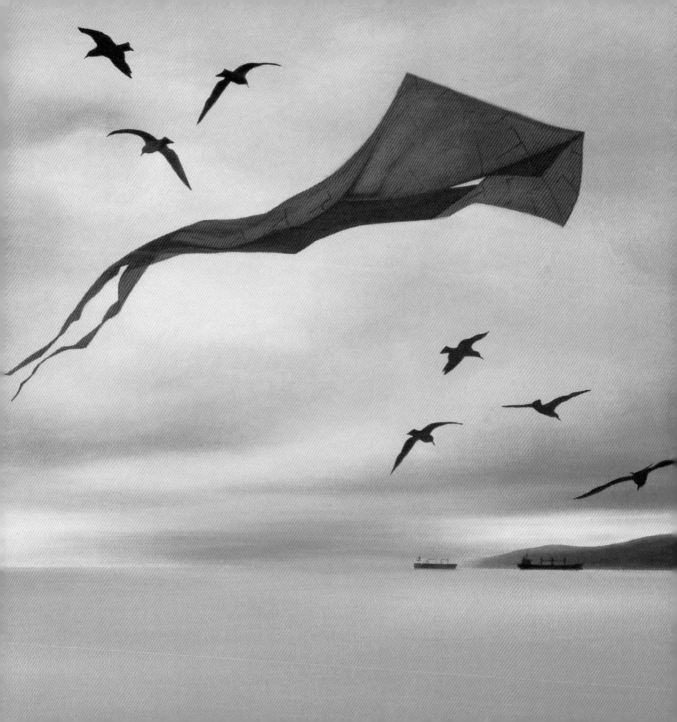

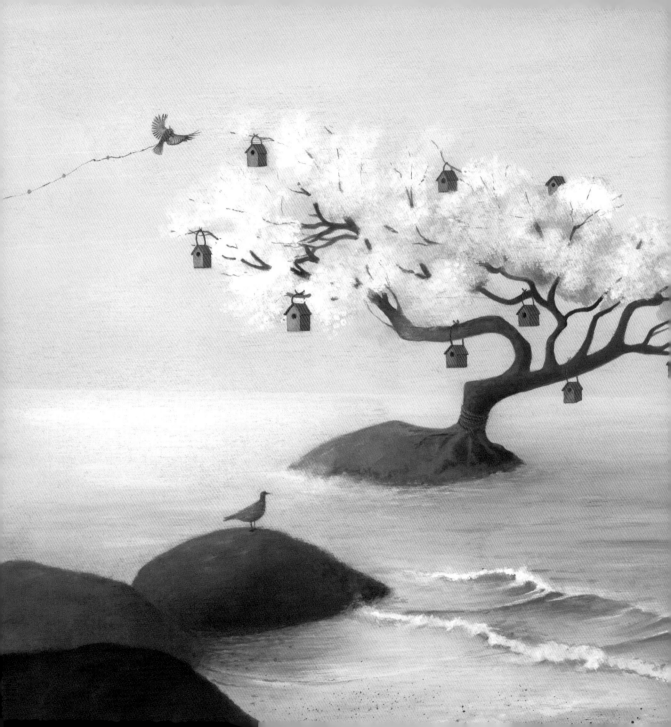

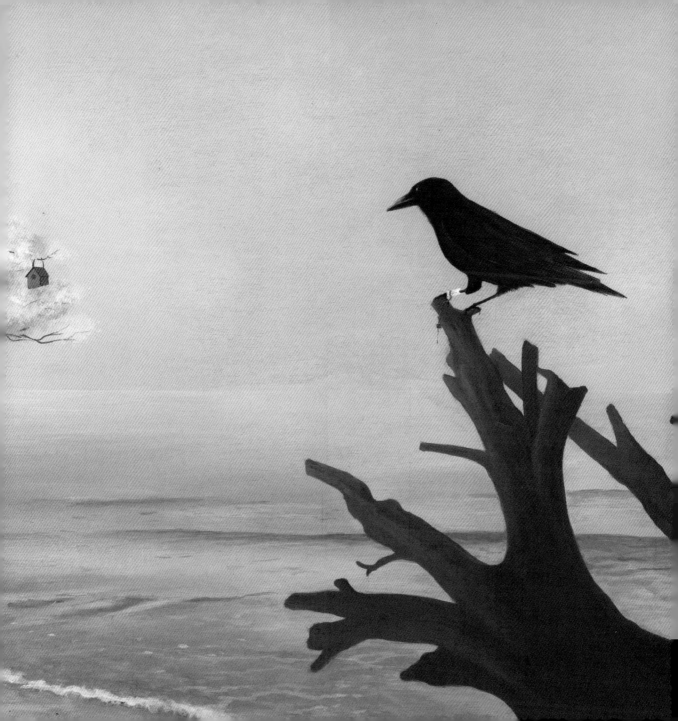

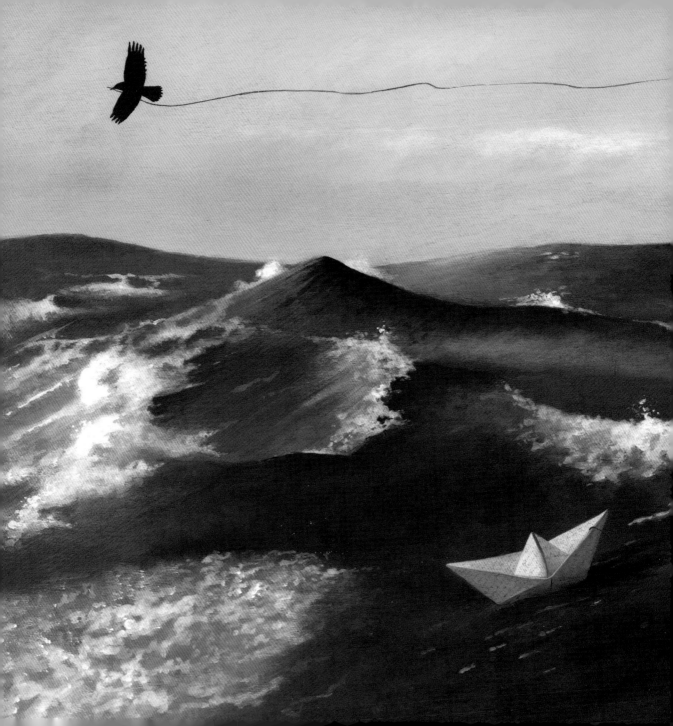

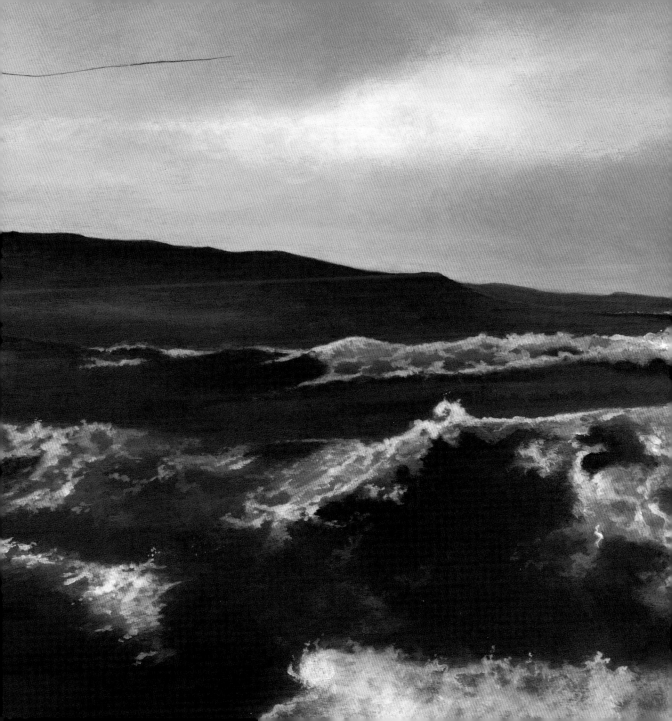

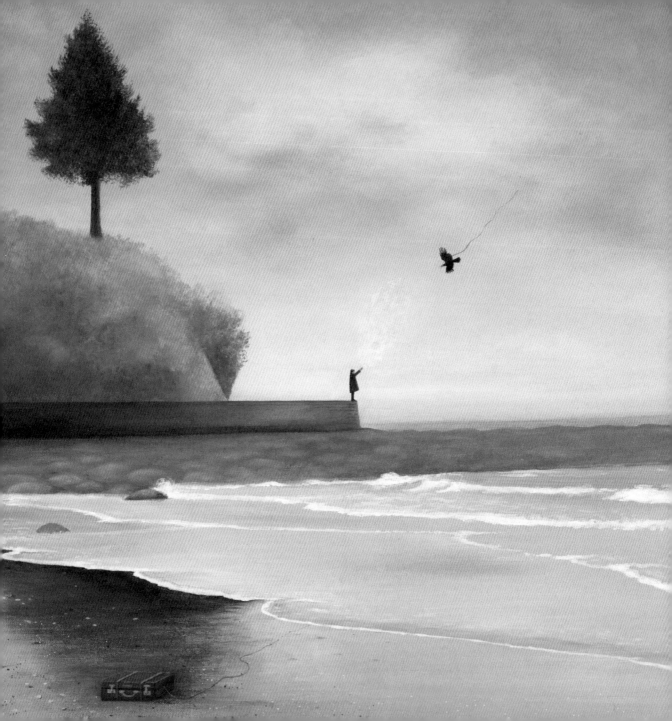

When a response arrives, it summons him to follow his heart.

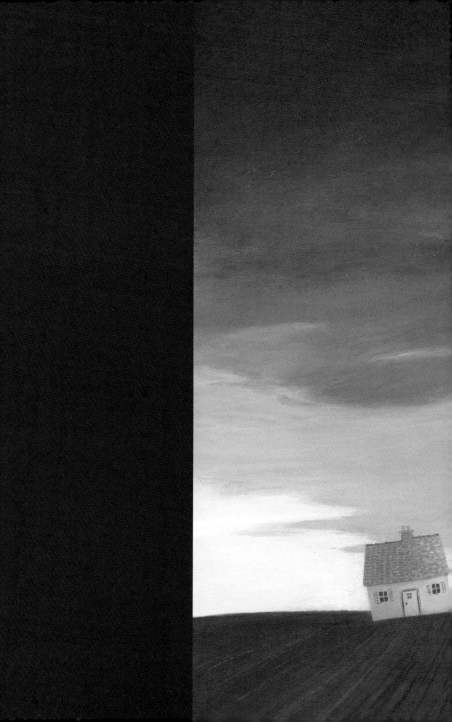

He sets off.

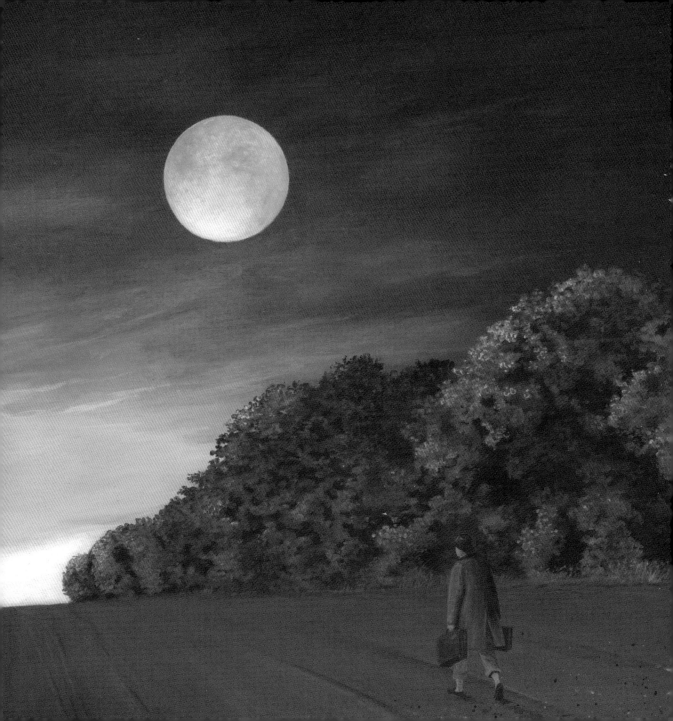

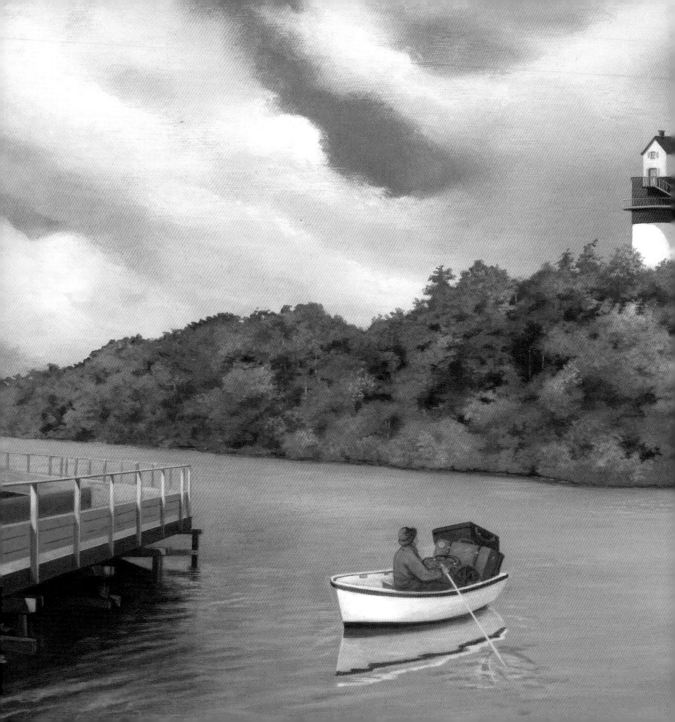

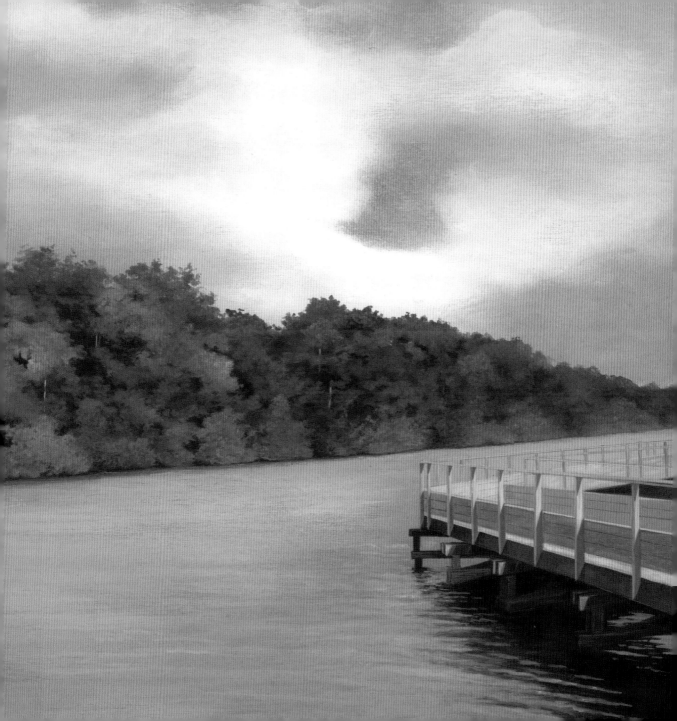

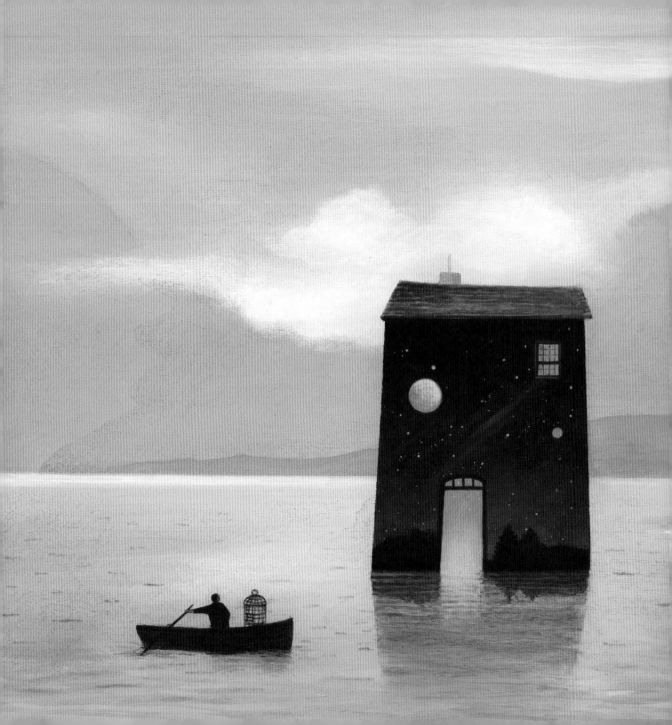

He enters a sea of dreams.

His heart flutters.

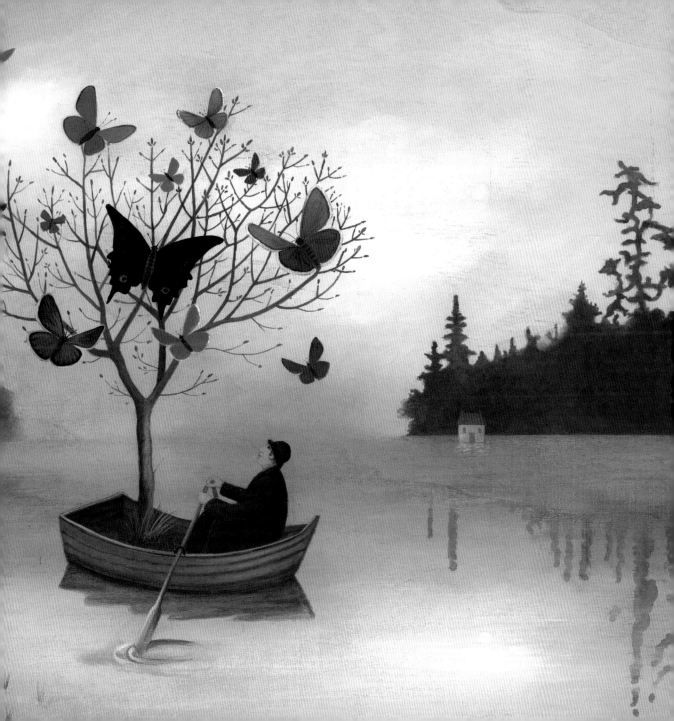

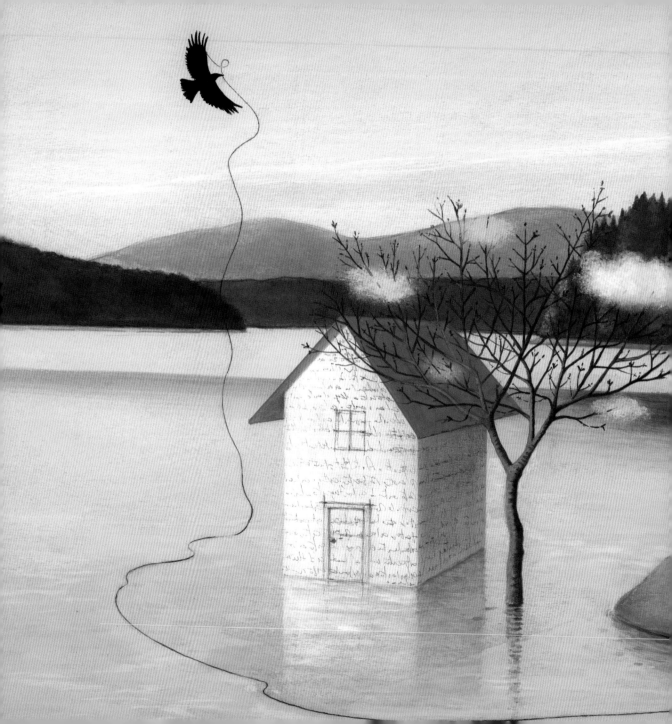

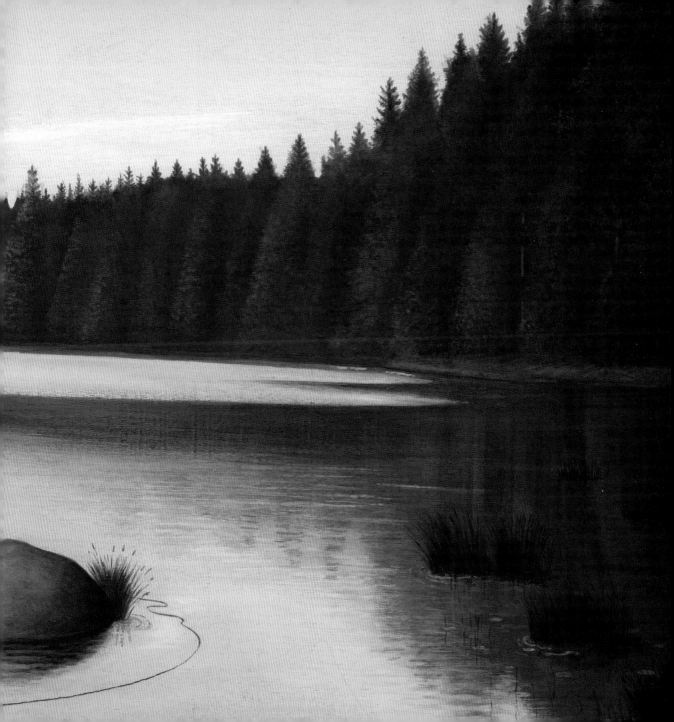

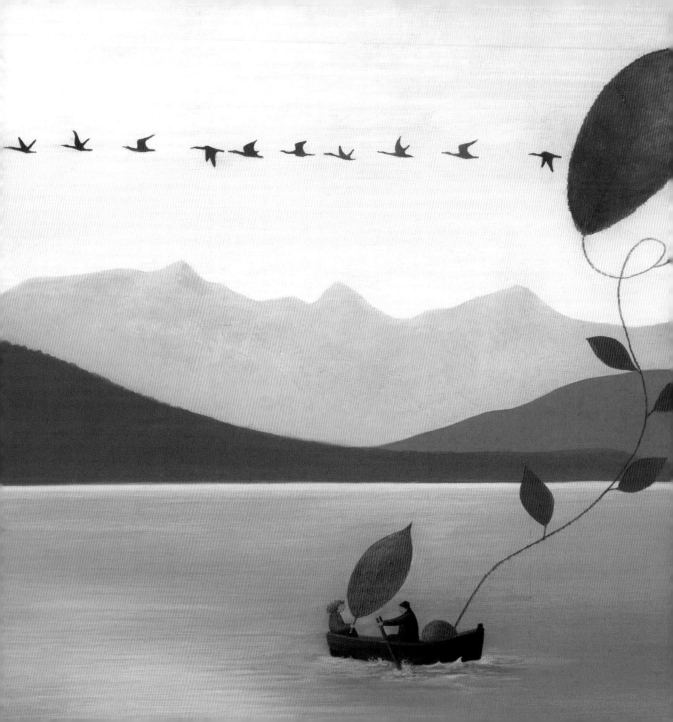

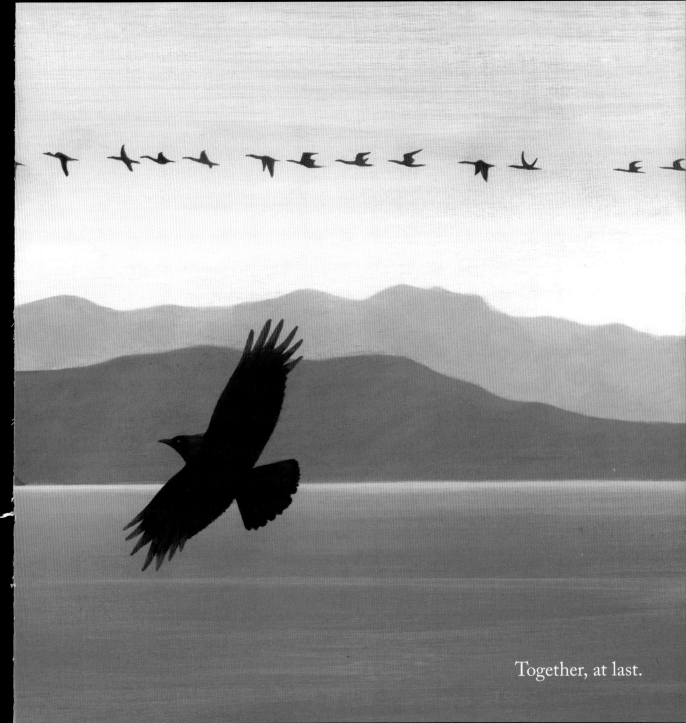

Together, at last.

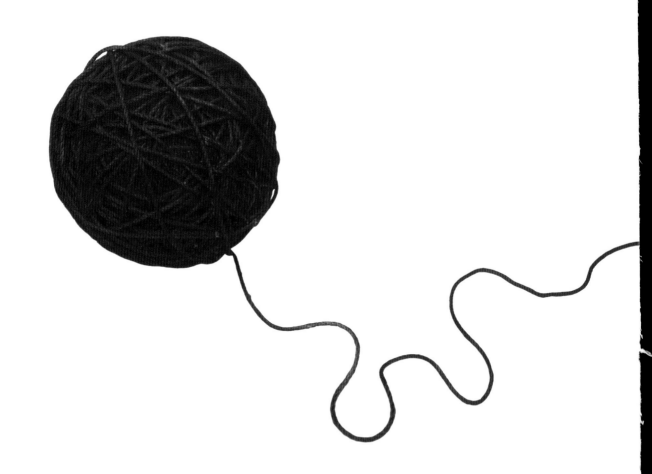

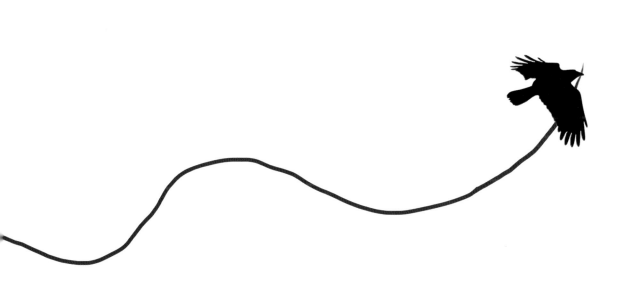

First published in 2013 by Read Leaf
an imprint of Simply Read Books

Library and Archives Canada Cataloguing in Publication
Meister, Soizick
 Mr. M and the red thread / by Soizick Meister ; with text by K. George.
ISBN 978-1-897476-88-8
1. Meister, Soizick. I. George, K. (Kallie), 1983-
II. Title. III. Title: Red thread. IV. Title: Mister M and the red thread.
ND249.M4446A4 2011 759.11 C2011-900652-9

We gratefully acknowledge for their financial support of our publishing program the
Canada Council for the Arts, the BC Arts Council, and the Government of Canada
through the Canada Book Fund (CBF).

Book design by Pablo Mandel / CircularStudio.com

10 9 8 7 6 5 4 3 2 1

Printed in Malaysia

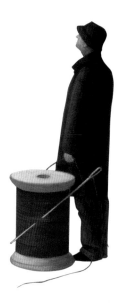